ALLISON SMITH: NEEDLE WORK

Essay by Wendy Vogel
Interviews with Lauren Adams and Allison Smith
—
Mildred Lane Kemper Art Museum
Washington University in St. Louis

DESCR. Acrylic paint on canvas,
gauze, cotton twill tape, in-
cised plastic, thread

REF. Anti-gas hood, early 20th
century

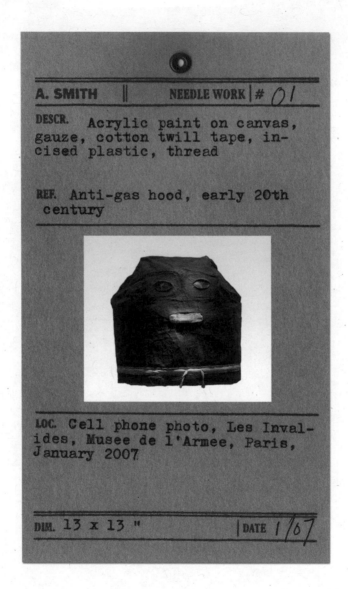

LOC. Cell phone photo, Les Inval-
ides, Musee de l'Armee, Paris,
January 2007

DIM. 13 x 13 " │DATE 1/07

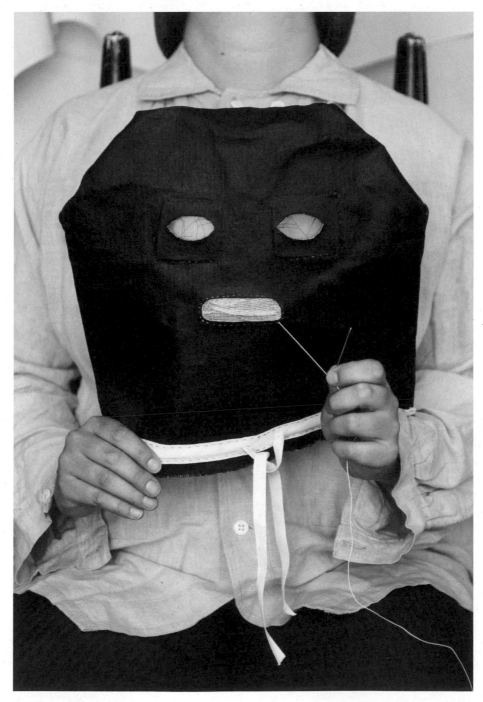

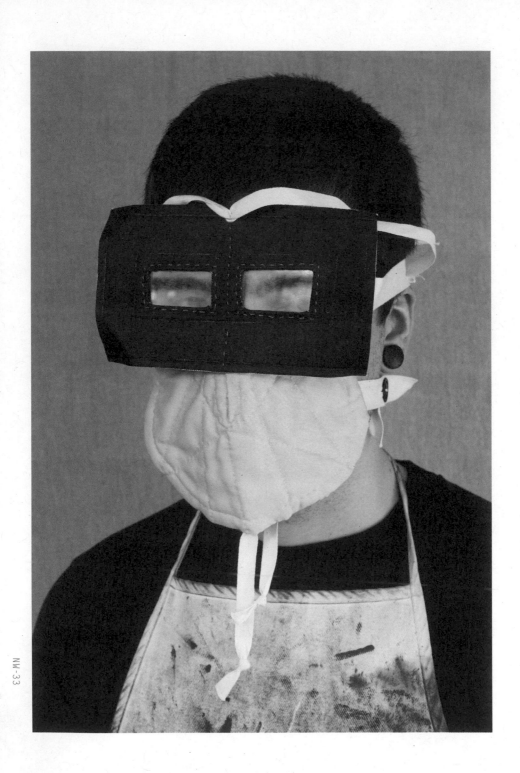

A. SMITH ‖ NEEDLE WORK │ # *33*

DESCR. Acrylic paint, chip board,
felt, plastic, cotton sateen,
twill tape, thread, metal button

REF. Goggles and mask used as
protection against gas attacks,
Western Front, c. 1918

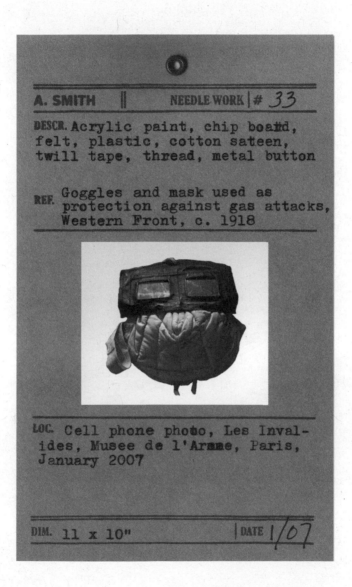

LOC. Cell phone photo, Les Inval-
ides, Musee de l'Arme, Paris,
January 2007

DIM. 11 x 10" │ **DATE** *1/07*

This volume is published on the occasion of the exhibition *Allison Smith: Needle Work*, organized by the Mildred Lane Kemper Art Museum at the Sam Fox School of Design & Visual Arts at Washington University in St. Louis, as part of the Henry L. and Natalie E. Freund Visiting Artist program, and in conjunction with the Sam Fox School's Island Press workshop.

Mildred Lane Kemper Art Museum
St. Louis, Missouri
February 5 – April 19, 2010

Support for *Allison Smith: Needle Work* was provided by Bunny and Charles Burson, the Henry L. and Natalie E. Freund Art Endowment Fund, Washington University's College and Graduate School of Art in the Sam Fox School of Design & Visual Arts, and members of the Mildred Lane Kemper Art Museum.

Printed in Canada.

MILDRED LANE KEMPER ART MUSEUM

Washington University in St.Louis
SAM FOX SCHOOL OF DESIGN & VISUAL ARTS

PUBLISHED BY

Mildred Lane Kemper Art Museum
Sam Fox School of Design
& Visual Arts
Washington University in St. Louis
One Brookings Drive
St. Louis, Missouri 63130

Editor:
Jane E. Neidhardt, St. Louis

Publications assistant:
Eileen G'Sell, St. Louis

Designer:
MacFadden & Thorpe,
San Francisco

Printer:
Printcrafters Inc.,
Winnipeg, Manitoba

DISTRIBUTED BY

The University of Chicago Press
11030 S. Langley Avenue
Chicago, IL 60628
Domestic:
T 1.800.621.2736
F 1.800.621.8476
International:
T 1.773.702.7000
F 1.773.702.7212

Library of Congress Control Number: 2009942917

ISBN: 978-0-936316-30-7

CONTENTS

9 ... NEEDLE WORK

10 ... INTRODUCTION
by Sabine Eckmann

14 ... EMBODIED MA(S)KING:
NEEDLE WORK
by Wendy Vogel

31 ... INTERVIEW: LAUREN ADAMS

39 ... INTERVIEW: ALLISON SMITH

47 ... PORTRAITS

64 ... ARTIST'S ACKNOWLEDGMENTS

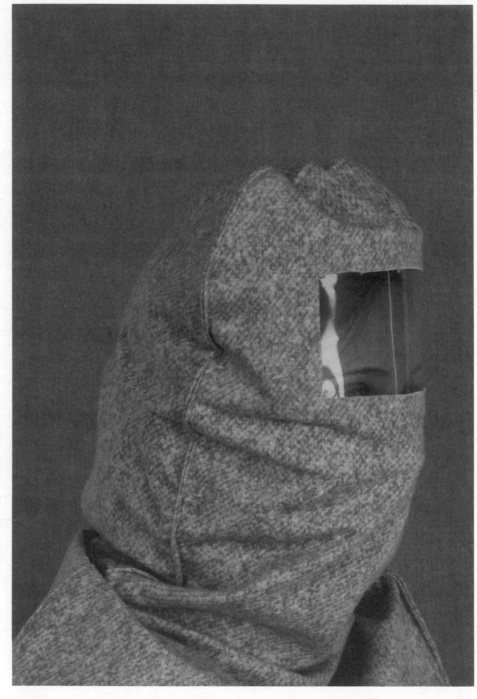

Mixed media installation of fabricated display cases containing
sewn reproductions of wartime textiles, dimensions variable,
with identification tags and research imagery; staged portraits
(NW 01–38), archival inkjet photographs on exhibition fiber paper,
22 x 16" each; and silk habotai parachutes with archival inkjet
printing, edition of four published by Island Press, approximately
11½' diameter each

Courtesy of the artist

Allison Smith was selected as the inaugural Henry L. and Natalie
E. Freund Visiting Artist in the Sam Fox School of Design & Visual
Arts. Working in collaboration with faculty nominator Lauren
Adams, assistant professor in the College and Graduate School of Art,
Smith concluded her residency with the exhibition *Needle Work* at
the Mildred Lane Kemper Art Museum. Importantly, the exhibition,
curated by Adams, comprises a large-scale installation consisting of
new objects that Smith developed not only in her Oakland, California
studio but also here on campus. Twelve students who participated in
the cross-disciplinary seminar "Past Perfect, Present Tense," taught
by Adams in collaboration with Smith, assisted in the development
of this exhibition. Additionally, the Sam Fox School's print workshop
Island Press collaborated with Smith on the production of *Needle Work*.
 Smith is known for creating large-scale performances and
installations that critically engage popular forms of historical reenact-
ment, along with crafts and other traditional cultural conventions,
to redo, restage, and refigure conceptions of the past. While Smith's
projects have frequently engaged US history through the appropriation
of traditional artisanry in order to articulate national identity anew,
Needle Work departs from this approach to probe how gas masks
may instantiate the tremendous experience of violence that through
technological and scientific advances penetrated the twentieth
century internationally on a yet unprecedented scope. Her typical
mix of historical subjects and contemporary American material culture
has been broadened by an inquiry into modern industrialized warfare,
especially the first international war to employ poison gas in modern
history, World War I.

Although Smith continues to deploy a form of installation art that challenges the medium of the exhibition to give meaning to historical memory, the subject matter has shifted in that the experience of violence itself is at stake. Handmade contemporary reproductions of early, factory made European and American gas masks enter into a spatial dialogue with parachutes and staged photographs of people wearing the newly fabricated masks.

Altogether this project asks if we can or cannot experience the violence associated with and embodied in the gas masks. This line of inquiry aligns Smith's interest with the significant contemporary discourse on historical memory as post- or secondhand memory. In fact, many of the images of historical gas masks that Smith used for her recreations were found on the Internet, as the tags of the new gas masks in the exhibition reveal. What is at stake here is the question of how far inadequate sources—reproductions on the Internet of originals that are incomplete and fragmented—can provide access to the past. While much postmodernist writing of the last decade has ensured us over and over again that history and memory, particularly as they relate to the trauma of violence, are unrepresentable and unapproachable, Smith challenges this through performative means that directly engage sensory experiences.

The Mildred Lane Kemper Art Museum is delighted to be able to present this thought-provoking and topical exhibition by the first Henry L. and Natalie E. Freund Visiting Artist in the Sam Fox School of Design & Visual Arts. We are foremost grateful to Bunny and Charles Burson and to Henry and Natalie Freund for providing essential support for this exhibition. Moreover, I would like to express my gratitude to Carmon Colangelo, dean of the Sam Fox School, and Buzz Spector, dean of the College and Graduate School of Art, fortheir support of and dedication to Museum programs.

Sabine Eckmann
Director and Chief Curator
Mildred Lane Kemper Art Museum

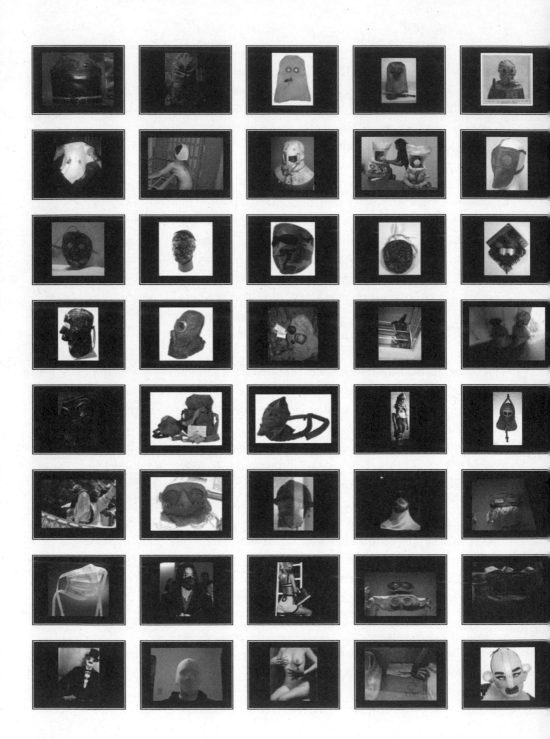

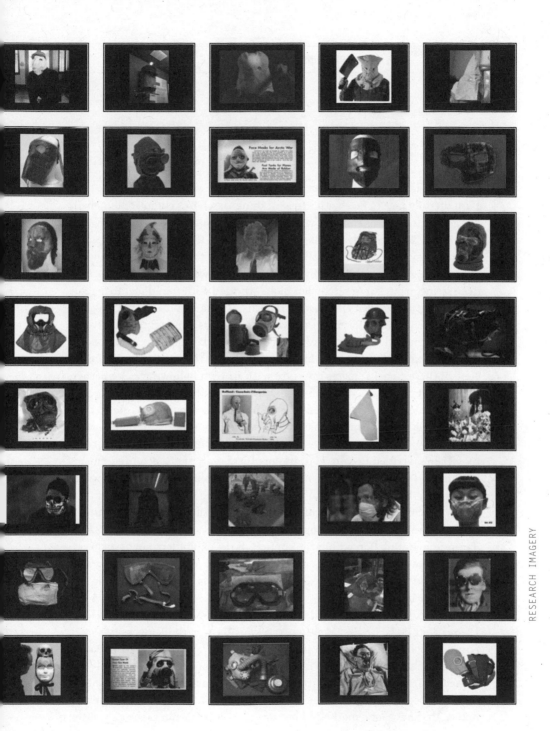

Wendy Vogel

I am literally face to face with a grid of images, whose crumpled, bunched, baggy, sagging forms contrast with the neatly black-framed boxes in which they are embedded. This is a digital face-off, a PowerPoint display on the glossy screen of my MacBook. I click the slide show function and move through the images one by one: first, a pillowcase with eyeholes and a drawstring; next, two scratchy felt blobs studded with round metal goggle-holes and stumpy cigars in place of mouths. Three images later, a caption underneath a similar form reveals what the powers of imagination have already surmised: "A near view of a trench helmet which gives the soldier the appearance of a ghoul." In humble cotton, metal, leather, fur, or glass, each of these "masks" meets my stare with its own hollow "eyes," whether alone on a table, donned by a mannequin, or worn by a human.

These masks, hoods, veils, and empty sacks are images collected by Allison Smith that form the basis of her research for the exhibition *Needle Work* (2009). They suggest a staggering array of contexts, from horror movies to sexual fantasy to, most importantly, war. Smith acquired most of the images from the Internet, and many of them retain a grainy or pixelated quality that betrays their origin as mass-circulated visual information. Smith also includes snapshots of cloth gas masks surreptitiously captured with her camera phone in European and American military museums. These images function within the context of the exhibition, not as a closed archive, however, but rather as an associative blueprint for Smith's own needlework: the recreation of early cloth gas masks used by soldiers in World War I.

Needle Work, conceived by Smith during her semester as the Henry L. and Natalie E. Freund Visiting Artist at Washington University's Sam Fox School of Design & Visual Arts, stems from her interest in early cloth gas masks as icons of an unwritten history of needlework, and by association, of the handmade in modernism. Returning to questions of historical reenactment, the conceptual use of craft, and making-as-performance that have long motivated her practice, Smith centers the exhibition

on handmade recreations of the masks that, while entrenched in a history of modern warfare, stubbornly resist a mass-produced aesthetic. Indeed, their modest appearance, closer to hand-stitched Halloween costumes than the mass-produced rubber masks worn by soldiers today, suggests a "functional inadequacy"[1] that invites purposeful misreadings. Neither militaria nor autonomous sculpture, the masks open up a vast web of psychic territory: a slippage in function between concealment, protective disguise, costume, and memento of war. *Needle Work* extends the line of inquiry in Smith's previous projects that invite direct participatory practice to an installation that attests to an embodied making-as-performance of historical objects.

Smith has considered the role of craft and war throughout her practice. She has been intellectually preoccupied by historical reenactment culture (also known as living history) and its relationship to craft traditions that often do not find expression in contemporary visual art discourse. Living history practitioners privilege "authentic reproductions" of the tools, props, weapons, and costumes utilized in reenactment. This stress on authenticity has inspired an entire subculture of "hard-core" reenactors who meticulously, if not obsessively, research their roles and objects, sometimes going as far as urinating on their jacket buttons to give them the proper patina. Smith, however, is interested in the practice of living history not only as a formulation of nationhood shaped by contemporary sociopolitical factors, but also for its reinvestment in the techniques and traditions of historical material culture. In other words, within reenactment culture, craft is not regarded simply as a feminized domestic activity, but rather as a vital aspect of performing patriotism—and especially for male reenactors, the values of "crafting" become virtuosic. This reverse gendering resonates with queering central to much of Smith's practice and informs the readings and display of recreated historical objects in *Needle Work*.

Smith's previous projects have burlesqued the traditions of reenactment culture, often reconfiguring them as participation-oriented public events within an art discourse informed by contemporary legacies of conceptual art, feminist practice, and relational aesthetics. She is also deeply invested in how notions of gender(ed) hierarchies may be subverted within the performative sphere of reenactment. In this way, Smith's process is linked to a notion of queering put forward by thinkers such as Eve Sedgwick and Judith Butler. Rooted in the poststructuralist idea of linguistic slippage as the site where new and subversive meanings are generated, queering refers to "the open mesh of possibilities, gaps, overlaps, dissonances and resonances, lapses and excesses of meaning when the constituent elements of anyone's gender, of anyone's sexuality aren't made

(or can't be made) to signify monolithically."[2] These slippages also occur in the production of a queered and insistent materiality in Smith's projects.

For instance, drawing on traditions such as wartime knitting circles and political stumping, Smith created a series of open-air protest events entitled *The Muster*, a project of New York's Public Art Fund, from 2004 to 2006. Participants were asked "What are you fighting for?," and invited to "muster" for their causes in self-fashioned uniforms and campsites against a stage set resembling the "aesthetic vernacular of the American Civil War battle reenactment."[3] Smith played the Mustering Officer, an androgynous figure who delivered rousing speeches and directed the activity. Another project that queered the notion of craft and its relationship to the economy of fine art, *Notion Nanny*, was performed by Smith, with London-based curatorial partnership B + B, from 2005 to 2007. The artist cast herself as an itinerant apprentice in homage to a genre of peddler dolls called "notion nannies," a tradition that commemorates the social custom of traders who traversed the land carrying baskets of handcrafted wares. Smith traveled to various English and American sites, setting up mini-residences, apprenticeships, and local dialogues with people about the politics of craft and economies of the handmade far beyond notions of the decorative.[4] And in another work, entitled *Hobby Horse*, commissioned by Artpace San Antonio in 2006, Smith wrote a melancholic song about the trauma of war to the tune of "When Johnny Comes Marching Home" and performed it while riding on a large handcrafted rocking horse—a tongue-in-cheek reference to war monuments of soldiers on horseback.

In keeping with Smith's earlier projects that have addressed specifically Anglo-American wars and reenactment traditions, *Needle Work* is comprised of a series of objects, some of which function as historical memory-triggers of the trauma of war. Recreations of early cloth gas masks, ready to wear yet installed within glass vitrines, are imbued with evidence of the history of their own making, or contemporary remaking, by military-style tags that reference the found photographic source imagery that Smith used to reconstruct them. The source imagery itself becomes the patterning on billowing silk parachutes installed within the space. Also included are photographs of the masks as protagonists captured in the process of their creation and "use"—with hands stitching them and bodies wearing them— as well as in tabletop still lifes that resemble anthropomorphized portraits. Similar to the toylike objects that have been the sculptural centerpieces of previous of Smith's installations (hobby horses, pull-toys, wooden rifles, dolls), the masks have an uncanny quality to them that can be experienced as both haunting and humorous.

The gaps and inconsistencies between the "authentic" and its recreation, between the ghoulish and the childlike, open up the associative play between the different types of masks included as Smith's source imagery. These images, willfully selected for their missing information as much as for their visual appeal, contain gaps in information that Smith mnemonically fills when recreating her masks. From the innocently costumelike (a burlap scarecrow's face) to the campy (performance artist Leigh Bowery pictured as a partially-veiled harlequin inexplicably topped with a skull "hat") to the ultimate luxurious and protective accessory (the ubiquitous black silk surgical mask like that donned by the late pop star Michael Jackson), the masks often indicate a precarious balance of positive and negative forces. Yet their dehumanizing aspects—as terrorist disguises (a Klansman's hood) and objects of humiliation and forced sexual submission (a pair of underwear over an Abu Ghraib prisoner's face)—also populate the images. It is in this commingling of horror and delight that the masks are placed in dialogue with the carnivalesque.

The Russian Formalist writer Mikhail Bakhtin proposed a theory of the carnivalesque in his work *Rabelais and His World*, a lengthy analysis of the then-little-known sixteenth-century French writer whose work reflects a medieval folk culture of humor. Bakhtin explains that for medieval subjects, carnival was an important part of social life. Unlike religious and feudal ceremonies, which sought to reinscribe sharp social divisions, carnival celebrated bawdy humor, a suspension of hierarchical rank, and spectacular imagery that blur the line between life and art: "It is life itself, but shaped according to a certain pattern of play."[5]

The role of the mask in this celebratory atmosphere is complex:

> The mask is connected with the joy of change and reincarnation, with
> gay relativity and with the merry negation of uniformity and similarity;
> it rejects conformity to oneself.... It contains the playful element of life;
> it is based on a peculiar interrelation of reality and image, characteristic
> of the most ancient rituals and spectacles.[6]

That is to say, the mask represents a blank slate to which any desire can be projected and any fantasy fulfilled—within the realm of the corporeal grotesque, which primarily concerned itself with the lower-body stratum functions of sex, digestion, and birth. The possibilities for gender-bending and queer sex implicated by masquerade (the wearing of masks) are endless. Bakhtin contrasts this definition of the mask as a prop teeming with libertine possibility to its Romantic form that "keeps a secret, deceives,"

its "regenerating and renewing element" transformed into a "terrible vacuum, a nothingness [that] lurks behind it."[7] It is this symbolism that Judith Butler also pursues, relating the queered mask to Jacques Lacan's psychoanalytic writing in her work *Gender Trouble*:

> The mask has a double function which is the double function of melancholy. The mask is taken on through the process of incorporation, which is a way of inscribing and then wearing a melancholic identification in and on the body; in effect, it is the signification of the body in the mold of the Other who has [been] refused.[8]

Liberation and shame are bound together as closely and seamlessly as the flip sides of a coin, as are the pain and pleasures of love and war.

Though the result of years of innovation and experimentation, the cloth gas masks used in World War I suggest a handmade, even improvised materiality due to their anthropomorphized forms and visible stitches. They can be linked in inverse relationship to another group of objects that are part of a hidden, personal aesthetic of early modernism: trench art, an array of objects created by male soldiers on the battlefields of World War I from war matériel, or the mechanical detritus of war. For soldiers as well as civilians, crafting served to pass the time while also addressing the trauma of war through nonverbal means. Just as communal bandage rolling, knitting circles, and other tactile traditions on the civilian home front sought to sublimate women's feelings of loss and anxiety into a productive, creative outlet, soldiers created their own "memory-objects" in homage to loved ones at home, their fallen comrades, or simply as objects of aesthetic value exchanged for food, cigarettes, and other useful items.[9] Trench art took many forms, yet much of it was overwhelmingly decorative, detailed, and feminized: pincushions, embroidered postcards, and vases created from artillery shells patterned with organic flower motifs.

Because trench art objects more closely resemble decorative art objects, however, they are not easily assimilable to the aesthetic discourses of either modern art or militaria (that is, artifacts of war that are preserved and displayed in military museums). For that reason, argues scholar Nicholas Saunders, they have been curiously absent from existing histories of war, and require a scholarly approach akin to material culture studies that also examine domestic crafts. Smith's masks, constructed from common materials readily available at craft stores and recreated from a series of blurry photographs, fall into a similarly iconoclastic category. They do not aspire to expert craft technique; nor do they appear as objects

that fit within a polished history of modern and conceptual art. But in
the slippages between the original masks and their recreations, a sense of
estrangement from this unwritten history of modernist needlework is
revealed. This reflects the very conditions of latency and modernity that
informed their production.

For Smith, a theoretical touchstone that connects gas warfare to
modernism is Peter Sloterdijk's *Terror from the Air*. In this text, Sloterdijk
links conditions of modernity (terrorism, product design, and environmental
thinking) to the conditions of gas warfare, assigning a date to the symbolic
dawning of the twentieth century: April 22, 1915, the day German troops
executed the first chlorine gas attack in World War I. By attacking the
enemy's environment instead of his body—that is, by engaging in acts of
atmospheric (atmo-) terrorism undetectable by the human senses until too
late—gas warfare transformed the modern subject's relationship to his or
her environment. When danger could be lurking invisibly in the air around
them, modern subjects could no longer take their natural environment for
granted.[10] Rather, even the most basic atmospheric conditions of life required
an "acceleration in explication" that resonated not only with modernism's
increasing dematerialization of art objects in favor of conceptual practice,
but also with the rise of discourses such as psychoanalysis that seek to reveal
the "background givens underlying manifest operations."[11]

Sloterdijk cites a key artwork demonstrating this new relationship
to atmosphere and product design: Marcel Duchamp's readymade object
Air de Paris, given by the artist to collectors Walter and Louise Arensberg
in 1919.[12] To create this work, Duchamp asked a pharmacist in Le Havre,
a town in northern France, to empty a perfume bottle, which he rechristened
as fifty cubic centimeters of Parisian air when he gave it to the Arensbergs.
And so, just as the air we breathe was reconceptualized from the introduc-
tion of atmo-terrorism not as a natural envelope, but as a penetrable mem-
brane that could be deadly, Parisian air is rebranded as a commodity fetish.

Duchamp's interest in ephemeral readymades continued in his
creation of the readymade perfume *Belle Haleine, Eau de Voilette*, endorsed
by his female alter-ego, Rrose Sélavy, in 1921. In this work, a label bearing
Rrose's portrait (Duchamp in drag, photographed by Man Ray) was applied
to a repurposed bottle of the exotic fragrance Rigaud. Couched in layers of
puns, the term "Belle Haleine," meaning "beautiful breath," also bears refer-
ence to "belle Hélène," that is, the mythical Helen of Troy. "Eau de Voilette"
reverses the i and o in "eau de violette," the French term for perfume, and
translates as "little veil water," hinting at Duchamp's veiled gender identity
in his masquerade as Rrose.

In Duchamp's work, Rrose's drag operates in an ambivalent—and queer—place.[13] Sélavy, clad in a fashionable feather hat, a bob-length wig, and a ruched-collar coat with a mysterious, off-center gaze, displays herself in a luxurious manner characteristic of the upper bourgeoisie. At the same time, "her" garishly lit, hawkish, masculine face suggests an inauthentic slippage in Rrose's self-presentation as the feminine ideal. Rather, it occupies a queer space between feminine "masquerade" and male "parade." In Duchamp's inhabitation of the "character" Rrose, he is not attempting to mock lower-class women (which has been suggested as a masochistic function of drag),[14] but rather constructs himself as the object of his own (queer) desire. This narcissistic desire to perform and possess the self-as-sexual-other defines the painful position of the dandy, a role often ascribed to Duchamp's practice.[15]

Rrose Sélavy's queered portrait functions *performatively* in two ways that are synonymous with Smith's photographs of the gas masks. Both portraits function not just as an index of a particular event (a legible performance), but as markers of a constructed subjectivity that is not fixed, but articulated over and over again in time to achieve materiality. This relates to theoretical constructions of queer performativity as addressed by Judith Butler: "Performativity must be understood not as a singular or deliberate 'act' but, rather, as a reiterative and citational practice by which discourse produces the effects that it names."[16] This process can as easily produce non-normative "performances" such as Rrose's drag and the coming-into-being of anthropomorphized masks. Just as Duchamp conjured the fictional author Rrose Sélavy through assigning her signature to various works of art (a nominal gesture as performance), he also manifested her visually in the photographic portraits (an interpellative gesture that "performs" her subjectivity as a female author).[17] In Smith's project, the mask photos not only stand as indexical documentation of a (making-as-) performance, but they also depict the masks' "performance" as protagonists inhabiting a space.

Moreover, Smith's inclusion of *hands* entering the space of the mask "portraits" places these images in a photographic tradition that symbolizes the notion of craftsmanship: the idea of "thinking with the hands" and a connection to a corporeal being dissociated from the analytical mind. That is to say, these photographs are self-consciously performing the fiction of a craft tradition. In a lecture entitled "Sleight of Hand: Directions and Displacements in Modern Craft," theorist Glenn Adamson debunked the notion of essentialized craft. It is craft's flirtation with the avant-garde, Adamson explained, that emphasizes its artificial nature as a separate

tradition.[18] By creating institutions of exhibition and reception like those for avant-garde art, such as museums and magazines, midcentury practitioners of craft asserted it as a separate, constructed sphere of production. Adamson, however, defines craft not as a medium but as a set of material and aesthetic concerns that carry forward to contemporary production. Smith's portraits reference this traditional notion of craft as a separate, bodily activity disconnected from intellectual concerns—but as a way of reclaiming the idea of embodiment in her practice informed by craft.

The contemporary notion of "craft," in all its tactile materiality, links Smith's *Needle Work* to the production of one of Duchamp's most irreverent successors, a female artist who prefers to be known only by her surname: Sturtevant. Retrospectively crowned as the first appropriation artist, Sturtevant began her career by creating what she calls "repetitions" of the most famous works by other (male) artists of the time. Beginning in the mid-1960s with Andy Warhol's Flower paintings, Sturtevant created the closest versions of her contemporaries' work as she could. Regarding her process, she states:

> It is imperative that I see, know, and visually implant every work that I attempt. Photographs are not taken and catalogues [are] used only to check size and scale. The work is done *predominantly from memory, using the same techniques, making the same errors and thus coming out in the same place.* The dilemma is that technique is crucial but not important.[19]

The ambivalent place that Sturtevant assigns technique, or craftsmanship, in her work is similar to Smith's reliance on subpar images and humble materials to recreate the masks in *Needle Work*. Furthermore, like Smith's subversive use of craft, Sturtevant's entrance into the game of modern art turned the rules of that game upside down. While other artists were charging themselves with the task of the genius to create new imagery, Sturtevant was preoccupied with fundamentally different questions of making, inhabiting, and self-positioning. As critic Bruce Hainley stated: "Through her exploration of the underpinnings of what the encounter and / or physics nominated as 'art' is, she dematerializes the primacy of the object and of the visual, but not by abandoning the object, the methods of its making, or even visuality itself."[20]

Rather, in her investigation of being-through-making (repetitions), Sturtevant challenged the frame governing the production, display, and markets of art. Sturtevant examined the canon of modern art and selected sources that best exemplify overall aesthetic progress. By choosing to

privilege the aesthetic discourse surrounding art, she elevates the discourse itself to an object of connoisseurship.[21] This refusal of traditional, male-encoded authorship in favor of an examination of the context of aesthetic creation also reflects a protofeminist orientation in Sturtevant's practice.

Yet the objects created by Sturtevant continue stubbornly to elicit visual pleasure and a sense of the artist's powers of transformation—the latter a purportedly unintended side effect.[22] These operations of aesthetic surprise equally apply to Allison Smith's *Needle Work* project. Though the recreations of cloth gas masks may at first seem utilitarian, there are moments of delightful inauthenticity when the masks seem to take on flamboyant, queer characteristics that are entirely their own. Shifts in scale, vibrant color choices, and the use of metallic fabrics elevate the masks tothe expression of a personal sensibility that, like Sturtevant's production, resists simple copying.

Needle Work, as an exhibition, works within and through the politics of reenactment. Smith's recreations of wartime effects on display—staged photographs, recreated masks, and recreated parachutes—subtly resist notions of polished "craftsmanship" while inhabiting the formal idiom of "craft." The masks, seemingly so "inadequate" and fragile to the ominous threats that surround them, allow us as viewers to take stock of our own human capacities and fears in the face of global wars still being fought. By recreating haunting objects on a personal scale and bringing them to the exhibition space through a queered, embodied sense of making-as-performance, Allison Smith might well pose the question of her *Muster* proposal yet again, but with a rejoinder: What are you fighting for, and how does your mask function? In the end, the masks are only a provocation. It is entirely in their reception that they do their painful needlework, getting under our skin.

Notes

[1] Allison Smith, email to the author, October 18, 2009.

[2] Eve Kosofsky Sedgwick, "Queer and Now," in *Tendencies* (Durham, NC: Duke University Press, 1993), 8.

[3] Allison Smith, "What Are You Fighting For?," http://www.themuster.com. Reproduced in Tom Eccles, Allison Smith, James Trainor, and Anne Wehr, *Allison Smith: The Muster: What Are You Fighting For?* (New York: Public Art Fund, 2007), 42-45.

[4] For more information on this project, see http://www.notionnanny.net.

[5] Mikhail Bakhtin, *Rabelais and His World,* trans. Hélène Iswolsky (Bloomington: Indiana University Press, 1984), 7.

[6] Ibid., 40.

[7] Ibid.

[8] Judith Butler, *Gender Trouble* (New York: Routledge, 1990), 50.

[9] Nicholas J. Saunders, *Trench Art: Materialities and Memories of War* (New York: Berg, 2003), 42.

[10] Peter Sloterdijk, *Terror from the Air,* trans. Amy Patton and Steve Corcoran (Los Angeles: Semiotext(e), 2009), 47-48.

[11] Ibid., 9.

[12] Ibid., 106.

[13] For more on ambivalent drag, see Judith Butler, "Gender Is Burning: Questions of Appropriation and Subversion," in her *Bodies that Matter: On the Discursive Limits of "Sex"* (New York: Routledge, 1993), 124-28.

[14] This has been theorized by writers such as Marilyn Frye in "Lesbian Feminism and the Gay Rights Movement: Another View of Male Supremacy, Another Separatism," in her *The Politics of Reality: Essays in Feminist Theory* (New York: Crossing Press, 1983), 128-51, and picked up more recently by writers such as bell hooks, who quotes Frye in her article "Is Paris Burning?," in *Reel to Real: Race, Sex and Class at the Movies* (New York: Routledge, 1996), 216-18.

[15] Robert Viscusi remarks on the dandy's poignantly "incurable sense of self-division" in *Max Beerbohm or the Dandy Dante: Reading with Mirrors* (Baltimore: Johns Hopkins Press, 1985), 30, as quoted in John Miller, "The Weather Is Here, Wish You Were Beautiful: The Persistence of Dandyism," *Artforum 28*, no. 9 (May 1990): 156.

[16] Judith Butler, "Introduction," in *Bodies that Matter,* 2.

[17] Butler, "Gender Is Burning," 121-23.

[18] See Glenn Adamson, "Sleight of Hand: Directions and Displacements in Modern Craft," http://www.saic.edu/gallery/saic_podcast/2009_trashtospectacle/gadamson (accessed November 21, 2009). This lecture was presented as part of the lecture series *From Trash to Spectacle: Materiality in Contemporary Art Production,* School of the Art Institute of Chicago, March 5, 2009.

[19] Sturtevant, "Interior Visibilities," in *Magritte (*Québec: Montreal Museum of Fine Arts, 1997), 124 (italics mine), as quoted in Bruce Hainley, "Erase and Rewind," *Frieze* 53 (June-August 2000): 84.

[20] Hainley, "Erase and Rewind," 84.

[21] Miller, "The Weather Is Here," 156-58.

[22] "People will [sometimes] say that a work looks better than the original. Then I say, that's totally wrong, it's not supposed to be better." Sturtevant, as quoted in Dan Cameron, "A Conversation: A Salon History of Appropriation with Leo Castelli and Elaine Sturtevant," *Flash Art* 143 (November-December 1988): 77.

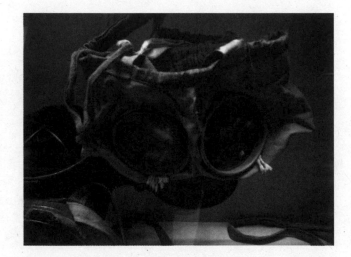

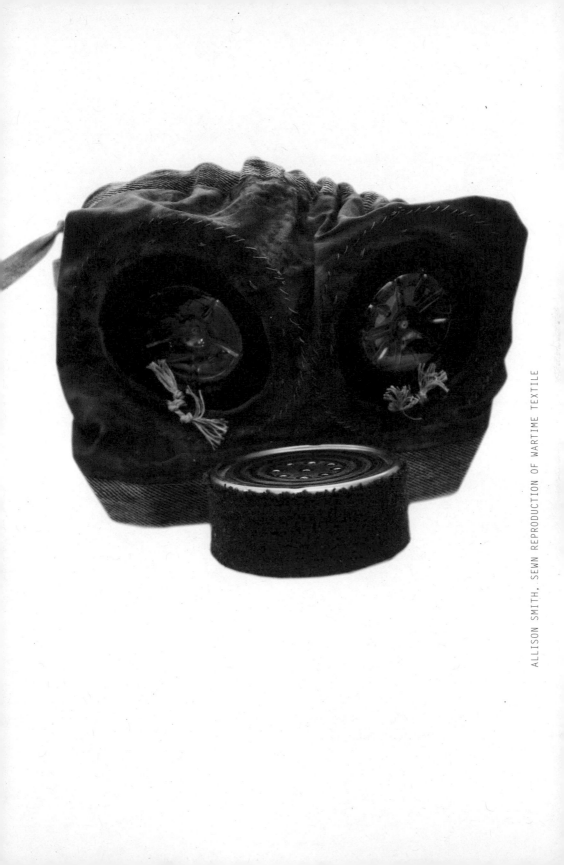

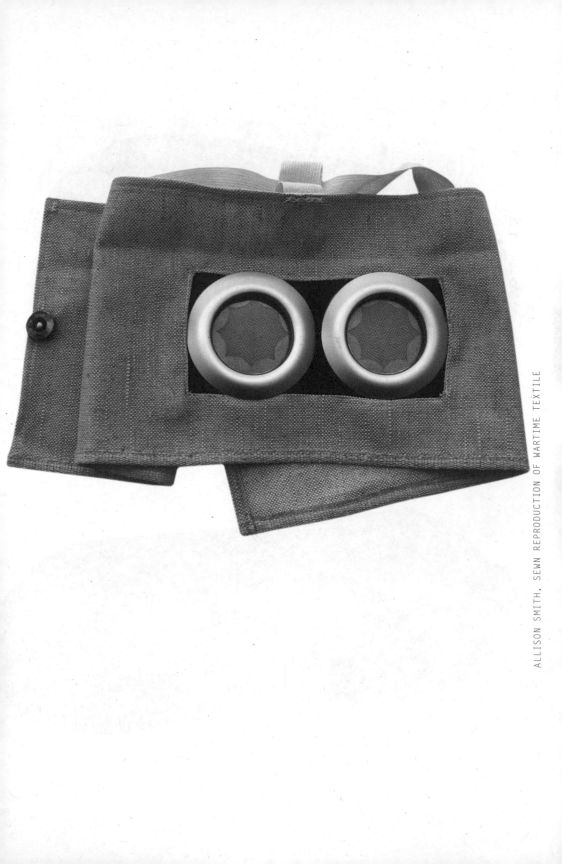

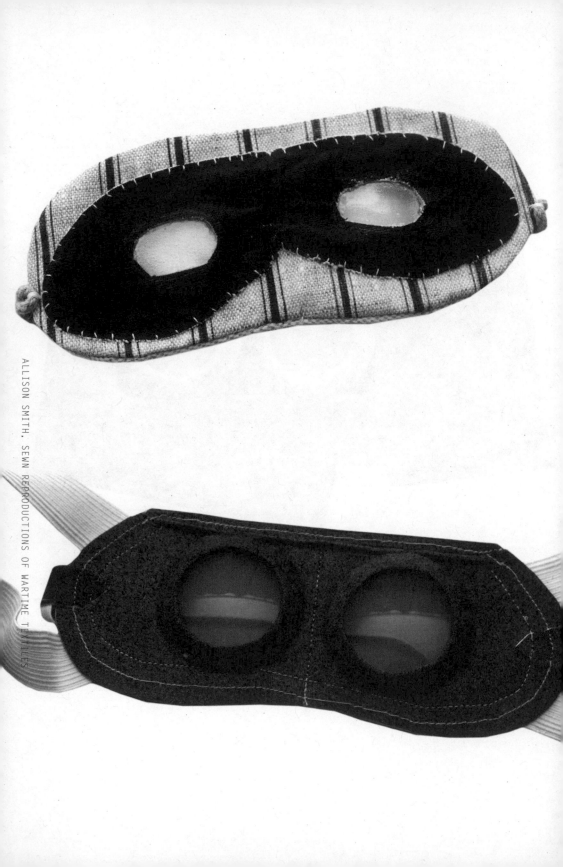

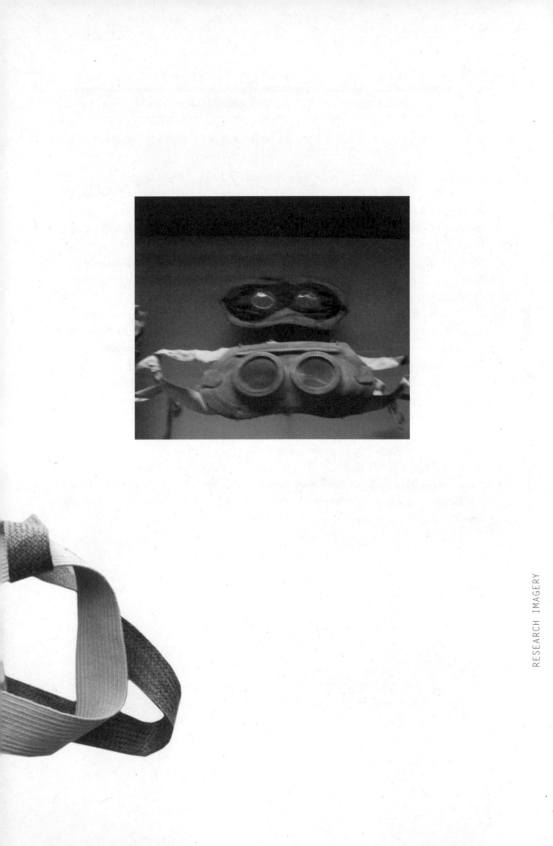

*Washington University's Sam Fox School of Design & Visual Arts
established the Henry L. and Natalie E. Freund Visiting Artist program
in fall 2008 as a partnership between the School's College and Graduate
School of Art and Mildred Lane Kemper Art Museum. The Freund Visiting
Artist program begins with a call for faculty to nominate visiting artists.
The selected artist collaborates in the classroom with the nominating
faculty member, who then curates an exhibition of the visiting artist's work
at the Kemper Art Museum.*

*The inaugural season of the Freund Visiting Artist program was
launched with Lauren Adams, assistant professor in the Sam Fox School's
College and Graduate School of Art, in conjunction with contemporary
artist Allison Smith, who made periodic visits to campus from San
Francisco, where she currently teaches at the California College of the
Arts. Their semester-long collaboration included the participation
of twelve Sam Fox School BFA and MFA students enrolled in the course
"Past Perfect, Present Tense" taught by Adams, as well as Washington
University's collaborative print workshop Island Press and the staff
at the Kemper Art Museum.*

*Managing editor Jane Neidhardt developed the following questions
for Lauren Adams and Allison Smith about this program and the culminating
exhibition,* Allison Smith: Needle Work.

LAUREN ADAMS

What made you want to be involved in the Freund Visiting Artist program? What does this mean for you?

LA: I wanted to be involved in this project because I saw a unique institutional effort to invite collaborative teaching practice into the Sam Fox School's contemporary arts curriculum. As an artist and educator, I was also interested in working as a curator, developing a project locally with a visiting artist, with the help of student input, and addressing historical and political issues. I have curated some in the past, mostly in nontraditional art spaces like a clothing label factory in Pittsboro, North Carolina, and an empty tailor shop in Pittsburgh, Pennsylvania, but I am aware of the subtleties and stipulations in the practice of professional curators, and I do not think of myself as a professionally trained or titled curator. Perhaps this would be more of an issue if I were curating an exhibition of an artist's existing work rather than participating in a work in progress. As it turned out, with this project I found myself in the roles of facilitator, co-teacher, and collaborator as I worked with Allison to help envision and produce her new body of work, and collaborated with students and Island Press.

What inspired you to propose Allison Smith as the visiting artist for this program?

LA: I most recently saw Allison's work at the Mattress Factory in Pittsburgh, Pennsylvania. That project, *Jugs, Pitchers, Bottles, and Crocks, Household Linens and Yardage in Stock* (2008), presented a contemporary response to historical Southern utilitarian objects, combining slogans related to the wars in Iraq and Afghanistan and the overall war on terror. I sensed an attention to the details of craft history and a willingness to fuse political concerns with everyday material culture. Other works by Allison, like *Pewter Sporks* (2001) and *Candlelight Bulbs* (1997–2002), also spoke to me. I grew up in the "New South," a place where colonial history collides with strip mall culture, and where global capitalism has almost wholly replaced a sense of regional "Mom-n-Pop" economies. I also identified Allison as a sister-in-arms, a member of a loose network of young artists around the country who are reflecting on American political and social histories and incorporating traditional craft forms into art practices.

I wanted to include Allison in a proposal for an exhibition at the Kemper Art Museum because I felt her concerns include a unique way of looking back at history to comment on the present. I felt this would be particularly appropriate in a Midwestern university museum context. I am

also a big fan of the politics evident in Allison's work, where feminism, colonialism, and American history play parts in a story that asks how we got here, and what is to be done now.

Could you comment more on the relation of Allison Smith's work to your own work as an artist, and to questions about art practices you are also exploring as an educator with your students?

LA: There are several themes in Allison's work that I share in my own studio practice and artistic vision. We are both interested in ideas involving historical and contemporary politics, the aesthetics and evolution of ethnic craft histories, domesticity and utilitarian items, and objects made during wartime, either as implements of war or in reaction to the terror of conflict and combat. Allison's work over the past several years has employed elements of display and representation in an installation context, mixing the domestic display tactics of curio cabinets and vernacular architecture with concerns of the marketplace or store. Her strategies encompass performance, activism, documentary photography, and the creation of objects that straddle the line between props and utilitarian items. In many ways, her work positions the gallery or museum as a theatrical stage, borrowing forms found in historical settings such as the military encampment, the town square, the market hall, the craftsman's workshop, and the living history museum.

Like Allison, I see great opportunity in mining the past for evidence of the development of political ideologies, such as French toile and regional American textiles, which historically featured Revolutionary-era and Civil War-era American scenes, and stretched well into the twentieth century, depicting, for instance, scenes from the film *Gone with the Wind* and important moments in Eisenhower's presidential term, to name a few popular examples. For quite some time I have viewed traditional decorative surfaces as intimately related to the history of painting and image-making. Working primarily as a painter, I interpret the evolution of hand crafts to reflect notions of modernity, and this provides a context in which to position a contemporary understanding of political propaganda as images with historical and social import. Allison's sculptural work functions for me as a take on some of the same themes. The artistic attitude of this approach involves a liberal use of the "copy," and a willingness to borrow from historical imagery and objects as a strategy for highlighting discrepancies and collusions between past and present conditions. I wanted to provide Allison's work as a model for the students to use for exploring archival research through object and image copying and performative reenactment.

How do you see the Visiting Artist program complementing or augmenting curricula on campus?

LA: The University's Sam Fox School has a strong tradition as an art school, so the Freund Visiting Artist initiative can be seen as a unique, though not unprecedented, way in which the College and Graduate School of Art reach out to artists from around the country and the world to foster new ideas in the local and regional Midwestern context. With the School's new focus on interdisciplinary studies, Allison's work seemed a particularly appropriate platform for conversations about performance, installation, and archival research, and the residency offers a unique opportunity for a different and multifaceted collaboration. Also, the opportunity to offer a new class, "Past Perfect, Present Tense," was a wonderful way to expand the School's focus on interdisciplinary studies that address vital theory and artistic models present in the contemporary art world, as well as provide a chance to look at how current culture reflects and absorbs historical issues.

The structure of the class followed the course of delving into one topic, or set of topics, and making a series of works related to it. Students in this course were engaging in a model of what you might call "slow art," somewhat different from a typical undergraduate class that asks them to focus on materials (ceramics, paint) and shift their conceptual framework for each assignment. This course invited students to select a single research topic and create a variety of works in various media connected to that topic. Participants included painters, performance artists, sculptors, photographers, and more; the underlying unity derived from how the students looked at history and collections, using archival research as a lens through which to explore collecting (amassing documentation), making (the physical), and performance (the body and its relationship to studio practice). Accordingly, the class was divided into three sections: "The Visible Collection," "Making Meaning," and "Performativity and Process."

How were students involved in the production and development of *Needle Work*, and, conversely, how did the course "Past Perfect, Present Tense" model the methods and practices of Allison Smith?

LA: Students participated in Allison's project through two venues: either as members of the "Past Perfect, Present Tense" class, or through Island Press as printmaking majors. Both of these student groups were afforded a unique window into Allison's work and the role of the Kemper Art Museum as a university museum. Working toward a museum exhibition created a kind of "learning laboratory" whereby students could witness the growth of a project from its roots in archival research to the resolution of installation, public display, and publication.

Hands-on participation included a sewing bee, where students, using kits that Allison compiled out of found objects, made masks for the mask collection component of *Needle Work*. On a different occasion (Halloween, coincidentally), Allison invited students to wear and perform the masks in the studio for the staged photographs that comprise another aspect of the project. Students also participated in the printing of the parachutes at Island Press. Exposure to the entire process profoundly influenced class discussions and provided an important point of reference for students as they worked toward their final projects.

The students' own work began with presentations of their nascent research as a "Visible Collection," a grouping of documents, images, and text relating to their chosen topics, which they formulated at the beginning of the semester. In "Making Meaning," students then looked at ways in which working with their hands—drawing, sewing, ceramics, collage—could influence the conceptual content of their research focus. We looked at the ways in which making copies of existing objects or images becomes a strategy for appropriation, in which artistic attitude defines the relationship between archival original and contemporary response. Allison's work making masks was an influential part of this process. Then, students looked to her performative photographs, as exhibited in *Needle Work*, as a way to explore "Performativity

and Process," which is about engaging the body and historical narrative, and can become an act of artistic ownership during the performative equivalent of the copy: reenactment. Shadowing Allison's studio practice allowed the students to see up close and firsthand the opportunities and challenges of this method as encountered by a professional artist even as they were applying the same strategies to projects of their own.

How do process and content—methodology and subject matter—interface in this particular pedagogical model?

LA: Some of the issues Allison's work explores—such as the very contemporary question of how to conduct research when your subject matter is spread across a vast global diaspora of war memorials and craft museums—became an opportunity to discuss how artistic research is not always a straightforward trajectory. In the case of the gas masks for *Needle Work*, for instance, Allison's research used the elusive provenance of Internet images as the basis for creating an alternative body of work, inspired by and critically investigating the history of craft during times of war. The exploration of this issue then becomes an object lesson for the art student in today's studio classroom, offering ways to consider how artistic creativity can borrow, and sometimes depart from, scientific research strategies. More than just an artistic strategy, this is

also a pedagogical strategy, one that invites students to sustain an investigation over several months, looking for larger patterns and narratives that can open into idiosyncratic, and sometimes conflicting, stories. As a professor, I am interested in how this aspect of art pedagogy can mirror issues faced by professional artists, when in-depth research opens up new worlds, and sustained and focused questioning of one set of topics leads the artist (or student) on a stimulating pursuit of question and answer.

What resulted from the students' own explorations during this course?

LA: Student research topics included the 1904 Olympic Games, held in St. Louis on Washington University's own Francis Field; the history of television and media violence and its presence in contemporary American society; the evolution of electrical technology and human attempts to harness energy power; a personal archive of band flyers and other underground culture ephemera; the role of expressive mark-making and the development of a personal visual language through a lifetime's handwriting as evinced in painting strategies; and Bloody Island, a strip of land in the Mississippi River between St. Louis, Missouri, and East St. Louis, Illinois, which served as a politically neutral site where American politicians from the nineteenth century would meet to duel as a way to settle scores, and also as a place

where African Americans could go to learn reading and writing, when such activities were either frowned upon or outright illegal.

The students' research processes included personal interviews (with Washington University professors and other academic archivists); library research (including archived national newspapers from the eighteenth and nineteenth centuries); and site visits to such places as the Missouri Historical Society (here in St. Louis), the Museum of Broadcast Communications in Chicago, and Pompeii, Italy (to research frescoes). In every case, it was important for the students to reach out to various sources for evidence and alternative perspectives.

Additionally, while the students were observing Allison's process develop toward an exhibition at the Kemper Art Museum, they were also working toward public display of their own work: the course culminates in an exhibition of the students' projects at Washington University's Des Lee Gallery, an off-campus gallery space in downtown St. Louis, bringing together the research, making, performance, and display in a final significant moment.

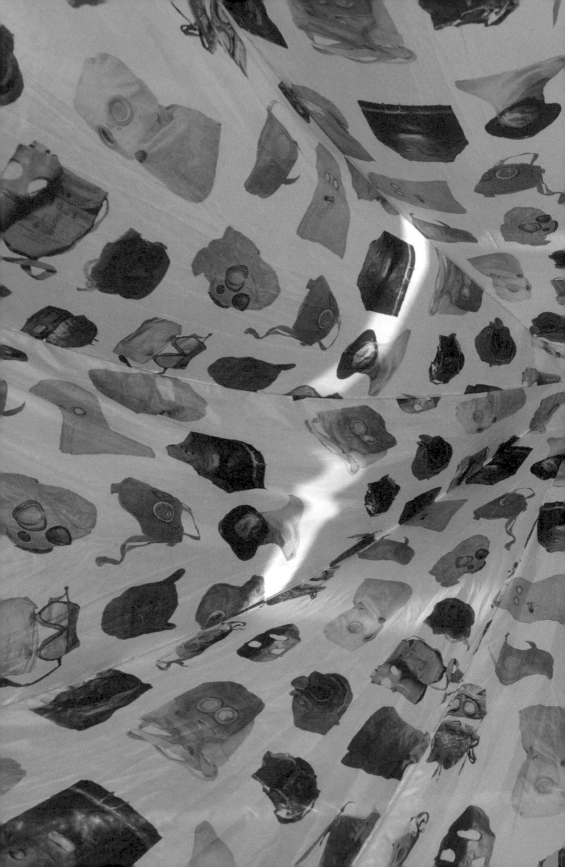

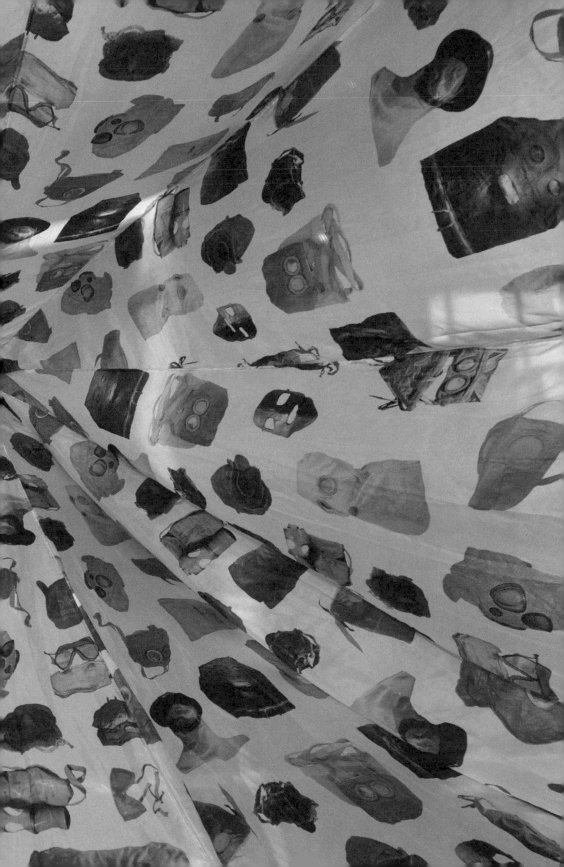

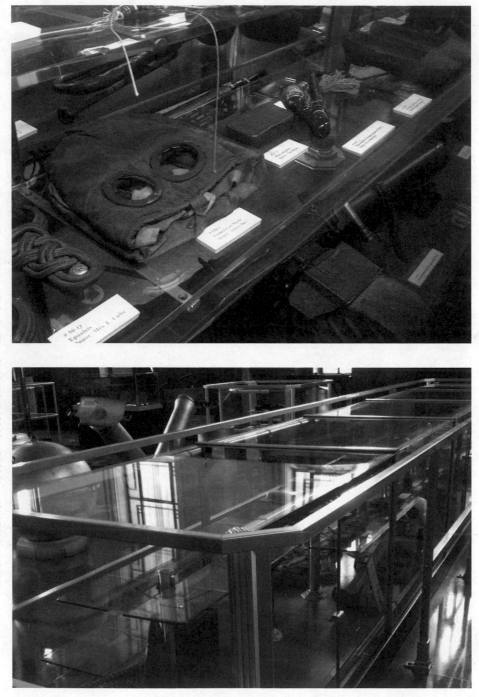

THIS PAGE: INSTALLATIONS AT THE ST. LOUIS SOLDIERS' MEMORIAL MILITARY MUSEUM
PREVIOUS SPREAD: ALLISON SMITH, SILK HABOTAI PARACHUTE. PHOTO STAN STREMBICKI

ALLISON SMITH

Many of the masks in *Needle Work* derive from early gas masks. How did you first discover these objects? What intrigued you about them and their history?

AS: For over a decade, I have been exploring the cultural phenomenon of historical reenactment and the role of craft in the construction of national identity. Whenever I travel I try to make time to visit two kinds of museums: open-air living history museums and military history museums. I am fascinated by the handmade militaria contained in these sites, whether they are relics of past wars or historic reproductions. To me, these objects are the narrative devices, or "props," that drive stories of war throughout history, and I'm interested in them as a form of sculpture. In order to record my thoughts and ideas, I usually carry a small sketchbook, and lately I have been using the camera function on my mobile phone as a discreet note-taking device. Several years ago, I was in Paris visiting the Musée de l'Armée, which is part of a complex of museums and monuments relating to French military history called Les Invalides; it originally served as a hospital and a retirement home for war veterans. I was initially drawn to the early gas masks from World War I for their uncanny, anthropomorphic quality.

They stood out to me amongst the other uniforms and weapons in the museum; they were like individual characters. They were not like the black rubber gas masks I had seen before, but were instead made of recognizable textiles like canvas and twill tape, recalling other kinds of masks, hoods, costumes, and veils. There was something both haunting and heartrending about them. To me, they seemed somehow lovingly made, and functionally inadequate. I was struck by the recurring thought, "someone made this," and I tried to imagine what that would be like. I began to think of them as evidence of an as-yet-unwritten history of needlework, and I felt compelled to begin remaking them myself. The pictures I took at Les Invalides were very dark and out of focus, and I soon found myself looking on the Internet for clarity. Although images of gas masks on the web are abundant, very little factual information accompanies them, which made the inadequacy of the pictures seem somehow fitting. This was not a subject that was going to come into focus easily.

How did you arrive at the idea of copying the masks using contemporary materials? What criteria drove your selection of materials?

AS: I wanted to make the masks using "available" materials, which meant things I had at hand in the studio or could easily buy at local fabric or craft retail stores and recycling centers.

I took pleasure in the process of imagining what materials had been used to make the original masks, and in searching for just the right contemporary approximation. In the world of historical reenactment, or "living history," the weapons, uniforms, and personal effects of soldiers are intensely researched in an attempt to materially recreate what war feels like. Some reenactors are called "thread counters," or even "cloth Nazis," and there is a great emphasis on "authentic reproduction," which necessarily means an emphasis on craft and skill. With this project, I knew that it would be impossible to find the exact materials that were originally used for the masks, and I became increasingly interested in the process of attempting to recreate something based on very little or inadequate information. Trying to discern a fabric's texture from a highly pixelated image, or trying to guess what was on the underside of a mask or how it attached to the back of the head, I was aware that there would be gaps between the original artifact and the reproduction that would result in moments of "inauthentic," but necessary, abstraction. In this process, the masks ended up becoming not only sanitized or domesticated, but perhaps also childlike: plainly stitched, unspoiled, stain-free, and (almost naively) awaiting use.

Historical reenactment often replays some of the most violent aspects of war. How does trauma or its revisitation inform your work, and in what ways do the masks address this?

AS: In several past projects, I've taken on various semifictional roles. I see this as a kind of embodied performance, in which I can heighten the theatricality of an activity or exchange through the use of costumes, props (by which I mean sculptures), and backdrops or platforms that are formally and aesthetically exuberant, thereby inviting participation. But I would not say that I have developed these alternate personae to the degree to which an actor working on a film, or a historical reenactor or a live action role-player, would. I am still "myself." As an early admirer of the work of Judith Butler, whose writings I devoured as an art student in the 1990s, I have looked to reenactment culture in my attempts to understand the performativity of identity.

With the violence of war at its center, battle reenactment involves the continuous reenactment of trauma, with the goal of making it as "real" as possible. I have often thought of this as parallel to the therapeutic process, in which one attempts to "revisit" a trauma in order to experience it, in essence, for the first time. Battle reenactment is a death you can walk away from. The masks I've made for *Needle Work* are both "uniform" and "costume," signifying both a condition of invisibility as well as the freedom

to not "be oneself" at moments of one's own choosing. This raises questions of agency. Soldiers sacrifice their individual identities for the sake of representing their country; reenactors sacrifice their contemporary identities for the sake of portraying history. The masks in *Needle Work* suggest varying functions, in which play-acting the real and the make-believe converges with expressions of personal style, while alluding to political, social, and environmental conditions that are both invisible and pervasive.

How did you come to perform the masks through photography? What solutions (and questions) were involved, and what is the intended relation of the remade mask to its performed presence?

AS: For me, the activity of making the masks is itself a performative gesture of attempting to capture a feeling or forge a connection to something distant and somewhat terrifying, however ultimately impossible that may be. I see this attempt as not unlike that of the many seamstresses who supply the material culture for the field of living history, which is founded on the idea that historical events can gain meaning and relevance when performed live in an open-air, interactive setting. I wanted to follow up this form of making-as-performance studio work with a kind of staged studio photography, in a series of intimate portraits and tabletop still lifes. I was interested in showing these objects, which

perhaps we would not ordinarily think of as having been made by someone, actually being caught in the act of their making. Some of the images show hands sewing, and others include the research images embedded within the photograph. I was interested in how these sculptures might live in photographs, and in how, through various formal and conceptual decisions, I might direct and complicate a viewer's reading of the masks, suggesting how they came into being and also how they might be performed, reperformed, reenacted, or rethought. I wanted to show the process of their handling as an active gesture, emphasizing this handle-ability in order to position the masks as props for demonstrating acts of survival, cruelty, modesty, camouflage, or disguise, with provisional immediacy. Finally, I wanted to engage with the masks in my own intimate psychological and emotional way, hopefully capturing the straightforward yet mysterious and uncanny quality of the original masks, if possible.

What other kinds of masks appear in the exhibition besides gas masks?

AS: As I was researching the original gas masks online in search of more information about them, I encountered other kinds of masks that were visually and formally similar, yet evoked very different and sometimes contradictory cultural associations, from suffocating torture to feminine

modesty. Also, in thinking about why I was drawn to a particular gas mask, I realized that often it was because it reminded me of something else—a pillowcase, a scarecrow, a Halloween costume, and so forth. I discovered various accounts of who invented the first gas mask, going all the way back to the Banu Musa brothers in ninth-century Baghdad, to the Cleveland inventor, businessman, and son of former slaves Garrett Morgan in 1914. In contemporary news media, we were seeing the black satin surgical mask worn in public by Michael Jackson before his death, and the hoods worn in quarantine by some of the first patients to be infected with the H1N1 virus. I decided to incorporate some of these masks into the project as part of the cumulative collection of artifacts I had begun recreating. And, in the process of reproduction, further associations emerged as I looked for useful materials, from sunglasses to scuba gear. Gas warfare is used for "cloud effect" and contamination, and I started to think about the metaphorical possibilities of the mask as filter—for political apathy, social paranoia, oppressive ideologies, and religious fanaticism.

How did you decide to incorporate the source imagery from your original research into the exhibition, and what is its relation to the contemporary object?

AS: I decided early on in the process of making this body of work that viewers should have some access to the original source imagery, in order to engage with the process of transformation that took place. Certain decisions are revealed that may be curious or even humorous to the viewer, depending on their own interpretation of the objects and imagery. This could have to do with material choices or scale shifts, for example, or other nuances such as the way that a faded photograph can result in the use of yellow or pink fabric. Aside from the first few masks I saw in person at Les Invalides, the majority of the objects in the exhibition were made from found images; sometimes these images were almost more interesting than the masks themselves and would inspire how I chose to rephotograph the newer version. One way that I decided to incorporate the research imagery into the show was to create military or industrial-style identification tags for each mask, using a thumbnail image of the original and whatever meager information I had found about each mask. These tags mark the masks as objects of investigation, part of a larger collection or archive. The other way I have used the research imagery in the exhibition is as patterning on the surface of the four silk parachutes.

How did the idea of making parachutes as part of the installation evolve in the process of creating this work? What is the relation between the parachutes, the masks, and the staged, performative photographs of the masks?

AS: When I originally visited the gallery in which my work was to be shown at the Kemper Art Museum, what I noticed first was its soaring ceilings, and I wondered how I could activate this upper gallery space. Initially, I thought about making flags or banners that would call attention to the light coming from a high row of windows. I tried to imagine an "event" that could take place in the space, at its center, in the air. When I was invited to create an edition with Washington University's Island Press, known for ambitious, large-scale, unconventional printmaking, I eventually arrived at the idea of making the parachutes. By that time, one of the threads of my meandering Internet research had unfolded— from early gas masks to feed sacks to Klansmen's hoods, to the Veiled Prophet and to wedding veils. Somewhere in my research I discovered the phenomenon of women making their wedding dresses out of silk parachutes that their fiancés had brought back from World War II, and, serendipitously, around the same time in Northern California two women friends of mine exchanged their wedding vows while seated upon a parachute. I think of parachutes as another wartime needlework tradition, a luxurious and perhaps feminine material contradiction to other aspects of war matériel. What I enjoy about the parachute as a sculptural form is that it is sculpted by air, and in this context, parachutes could be read as veils for the gallery space, or even for the viewer.

Throughout your work you connect the historical with today. What role, if any, do contemporary events play in the formation of your work and your historical inquiries?

AS: I recently read Peter Sloterdijk's book *Terror from the Air*, in which he marks the beginning of the twentieth century and modern terrorism to the first-ever use of chlorine gas as a combat weapon. According to him, everything changes in this moment, from warfare as an attack on the physical body to warfare as an attack on the enemy's environment—the air itself—in essence, the very conditions for living. I am thinking about the invisibility of modern and contemporary forms of warfare (gas, biological, chemical, germ, information) and the accompanying anxiety and fear that produces. These masks are filters for an invisible threat, an environmental fear. I remember that shortly after the terrorist attacks on the World Trade Center on September 11, 2001, in New York, police officers on the subway system began wearing a new accessory: a large black nylon pouch strapped to the upper thigh. It was a noticeable addition to their everyday uniforms.

I was extremely curious about what might be inside these pouches, and one day as I was exiting the train I noticed one of these pouches sitting on an office chair that had inexplicably appeared on the subway platform. Without thinking, I grabbed the pouch and slipped it into my bag. My heart was pounding as I walked home. As soon as I entered my apartment, I opened the pouch and was shocked to find that inside was, in fact, a gas mask sealed in plastic. I wondered, if this was considered an effective form of protection for police officers, why then aren't all of us being told how to protect ourselves in similar fashion? Instead of feeling comforted by this extra layer of "security," knowing what was inside of these pouches inspired in me a whole new level of fear.

In your previous work you have focused on the eras of the Civil War (*The Muster*) and the Revolutionary War (*Notion Nanny*), and now in *Needle Work* you touch on World War I as well. How do themes of war and craft inform your past and current work?

AS: I have arrived at my current work through a long consideration of the connections between war and craft, coming out of my investigation of the field of historical reenactment and living history. In every project I do, I look to the past in order to understand the present. In previous wars, rolling bandages and knitting socks and mittens for soldiers was a way for civilians to feel a corporeal connection to the war effort and a "direct line" to soldiers themselves. What better path toward empathy than to roll a bandage to heal a certain wound? Not only did this satisfy a sense of civic participation, it also provided an outlet for anxiety, something to do with "idle hands." I'm thinking about the contemporary ethos of disconnect from war in general, of war as something far away, mediated, technological, and largely virtual —even camouflage is a pixelated pattern—and wondering how connections can be forged through tactile processes. To me, there is a homemade aesthetic to the early gas masks. But the fact is that hundreds of thousands, if not millions, were manufactured in factories during World War I— fabric soaked with water, treated with chemicals, coated with rubber. The early gas mask is a site where mass production meets mass destruction, a simultaneous doing and undoing that is unfathomable to me.

How did your visits to St. Louis and working at the Sam Fox School influence your artistic process?

AS: I initially spent some time as a tourist in St. Louis in search of a particular site-specific subject, visiting the Museum of Westward Expansion, the Missouri History Museum, the Griot Museum of Black History and Culture, and the Eugene Field House and St. Louis Toy Museum, among others. I was most compelled by my visit to the St. Louis Soldiers' Memorial

military museum, which houses what seems to be an uncurated collection of war-related artifacts within two light-filled rooms and a series of glass cases. I imagine that these objects were donated over the years by St. Louis families of veterans, which gives the collection a certain quirkiness but also fills the space with a palpable sense of loss. There are many disturbing and curious objects in the museum, and it inspired my thinking about the masks themselves as an incomplete collection or archive-in-formation; in fact, the glass cases displaying the objects and ephemera in *Needle Work* are contemporary remakes of the vitrines at the Soldiers' Memorial.

On multiple trips to St. Louis from my studio in California, I tried to share my creative process with the students at the Sam Fox School, from the inception of ideas to the final exhibition. In the "Past Perfect, Present Tense" class, we had some powerful discussions about the very idea of artistic research, which is not necessarily academic or scientific, can be totally subjective (even at times reckless), and is ultimately not about delivering answers but about asking more complex questions. For this project, I chose a subject that is factually hard to pin down and for me, psychologically and emotionally complicated; at moments I know that I have wanted to keep myself "in the dark." I work with many students who say that they cannot comment on war because they have never been in one. This,

too, is a form of keeping oneself in the dark, for as long as war is perceived as something happening in the past, or on distant lands, we can imagine ourselves as out of range, in the clear, unaccountable. It is a privilege not to "go there," not to acknowledge the trauma in our midst, to remain dissociated. It is this presence of war that I would like to articulate in *Needle Work*, the everyday terror "in the air": the camouflaged, pixelated, blurriness of wars that we are currently living and making and that, like low-level anxiety, internal conflicts, or regressive impulses, we actively prevent ourselves from seeing. A hand-stitched gas mask. Someone made this. See the thing that someone made. See it again, for the first time.

A. SMITH ‖ NEEDLE WORK | # *02*

DESCR. Cotton flannel, rubber gas-
kets, carpet protectors, linen
tape, plastic tubing, staple

REF. Gas mask hood, P.H. helmet,
United Kingdom, c. 1915

LOC. Cell phone photo, Les Inval-
ides, Musee de l'Armee, Paris,
January 2007

DIM. 22 1/2 x 17 1/2" | DATE *08/07* ◄

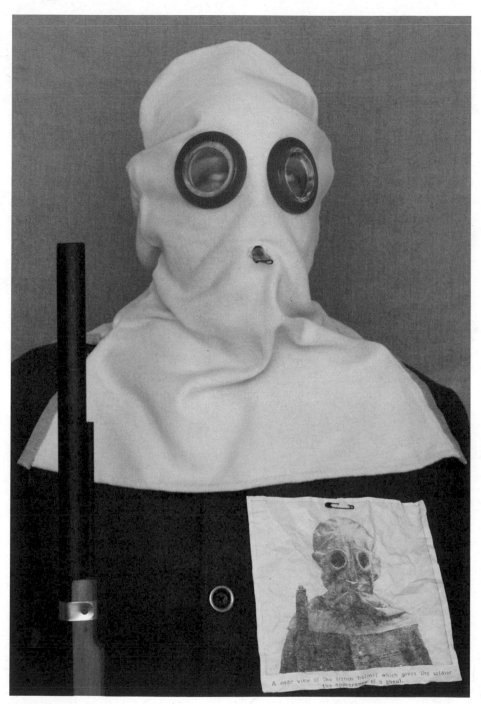

A near view of the French helmet which gives the soldier the appearance of a ghoul.

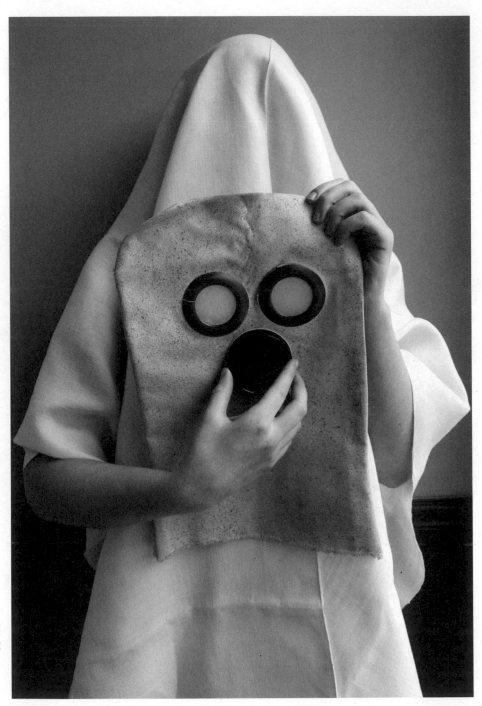

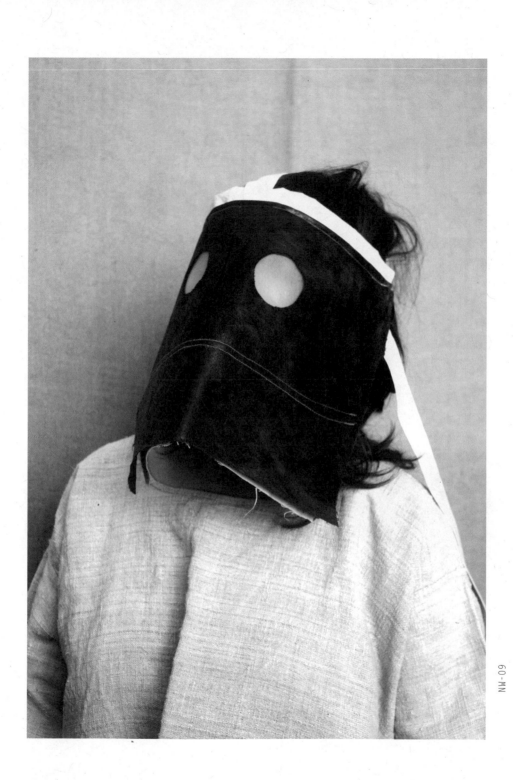

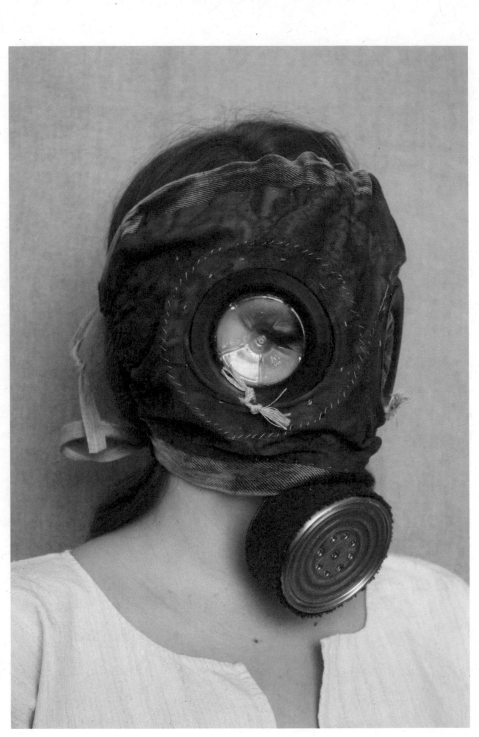

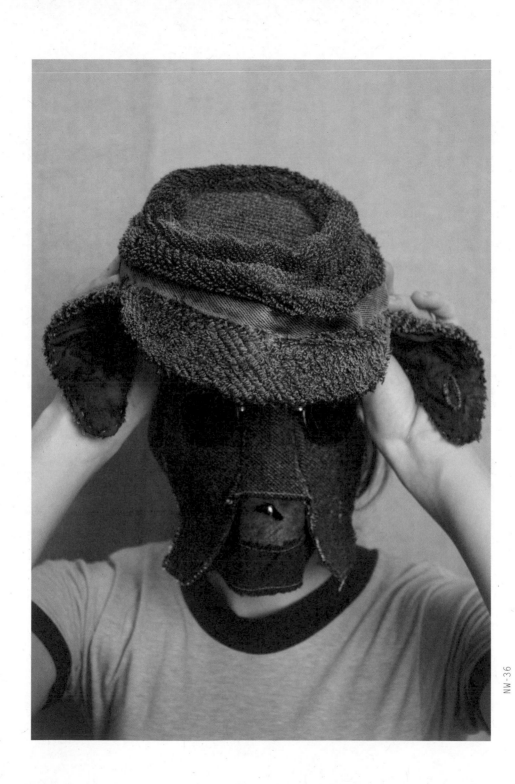

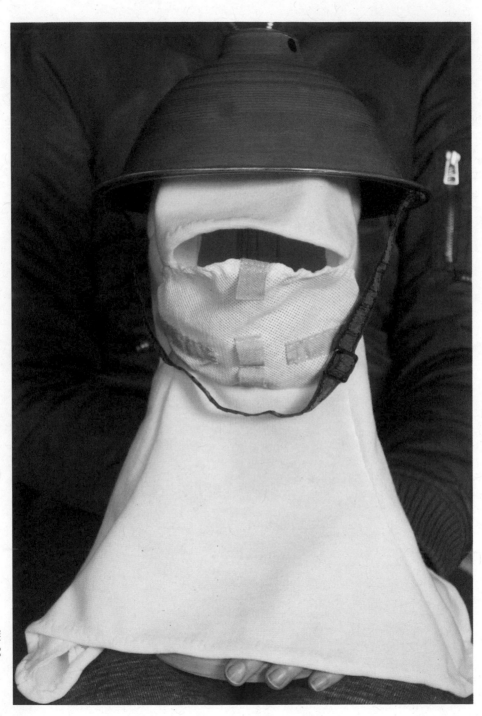

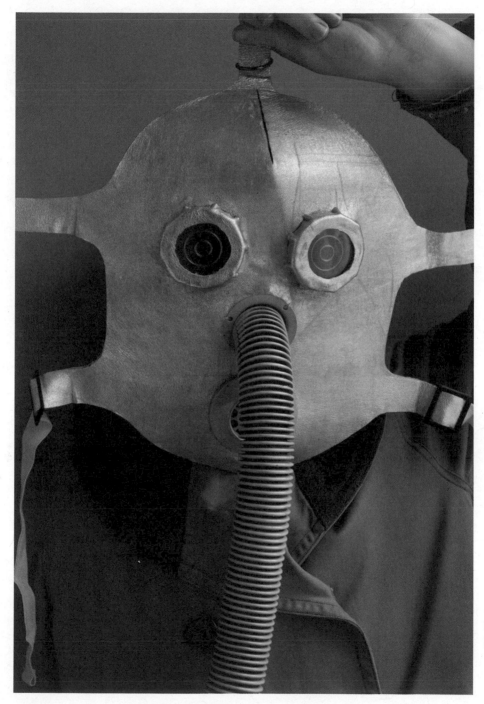

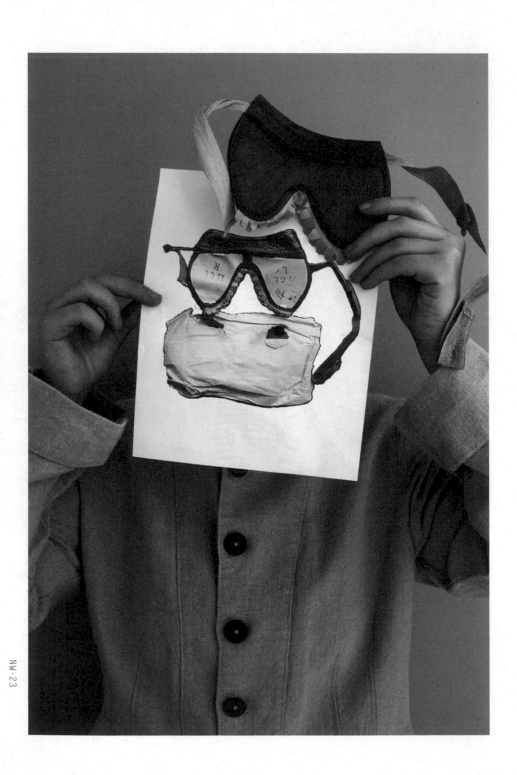

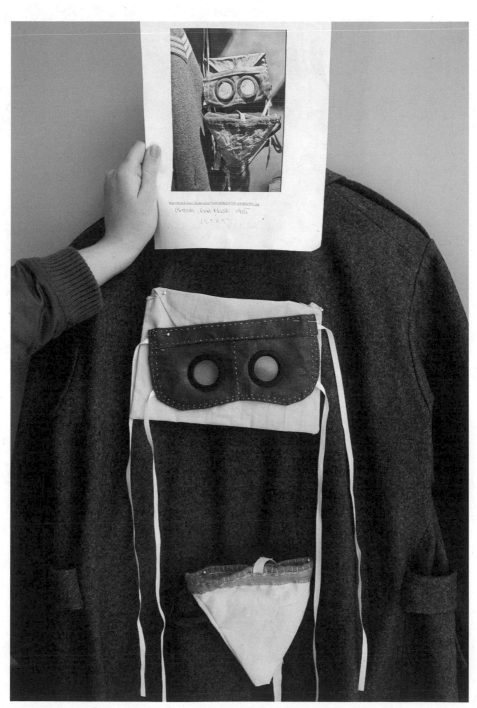

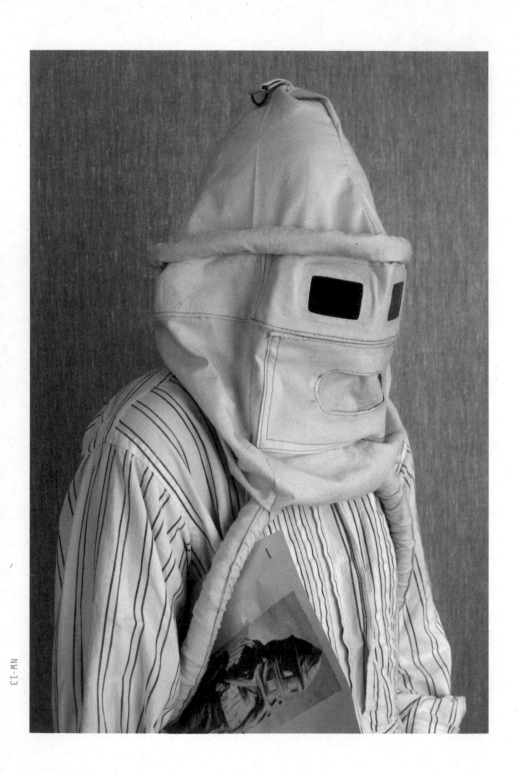

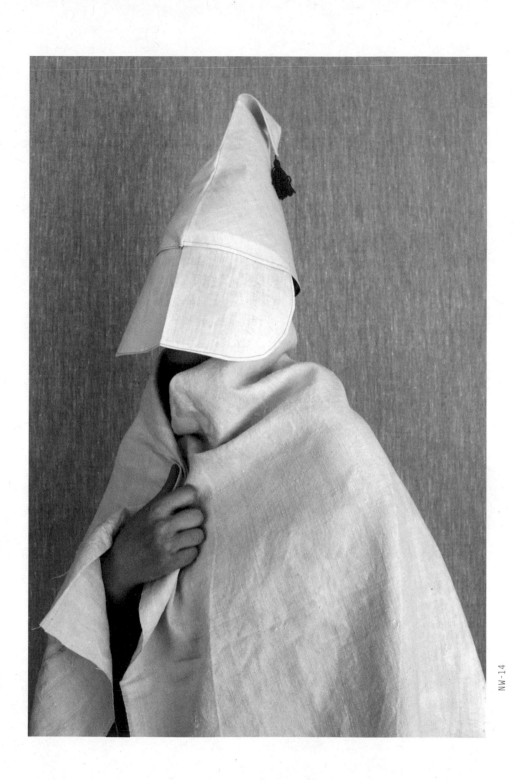

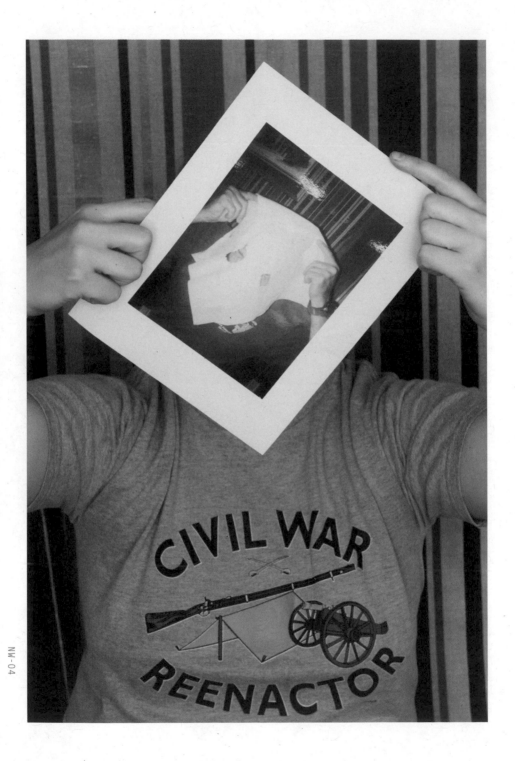

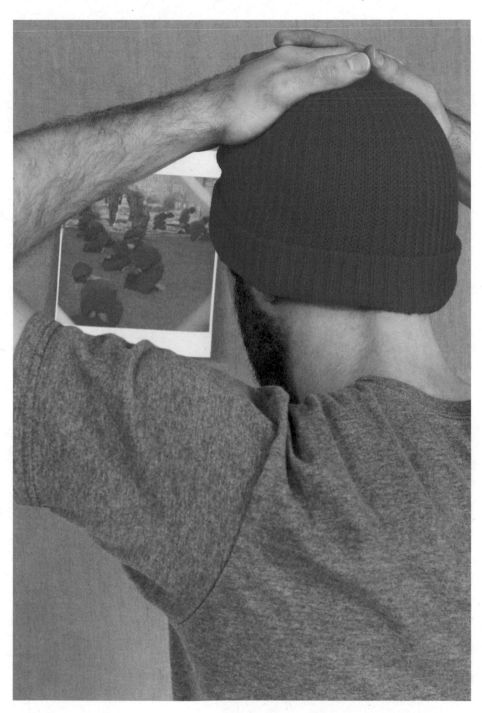

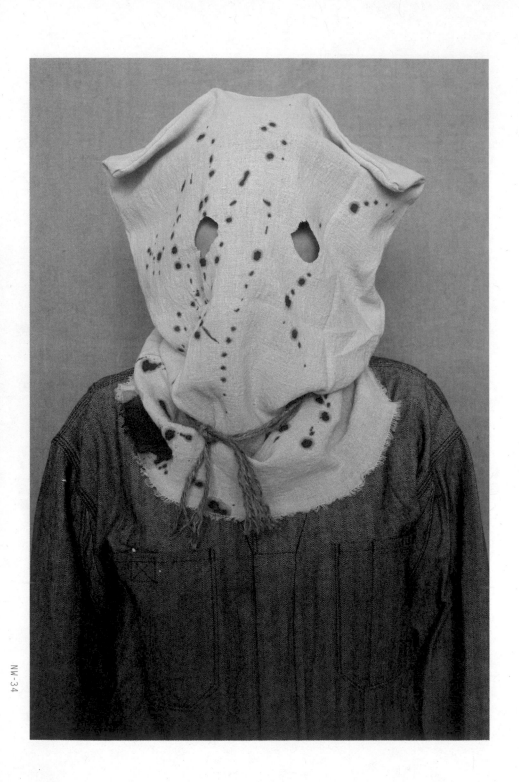

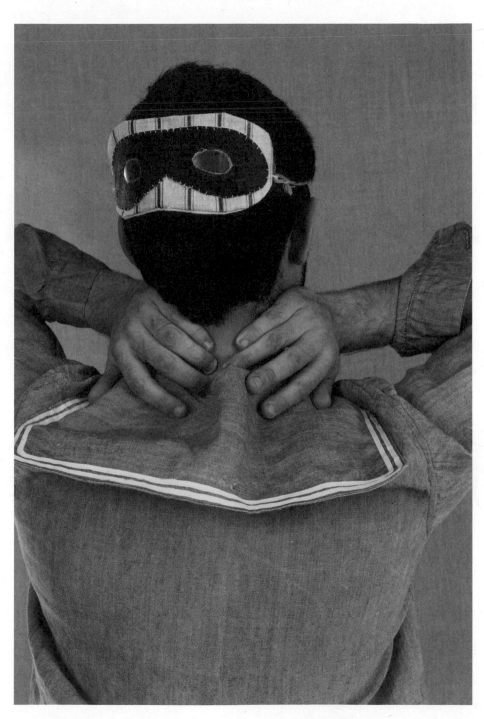

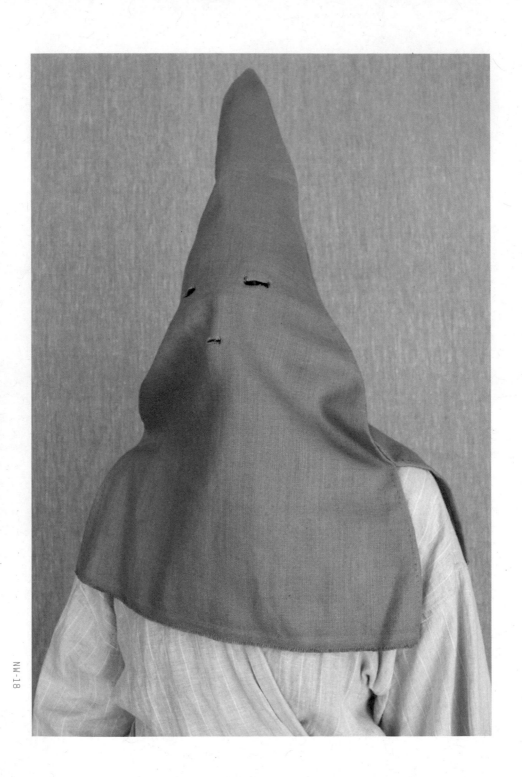

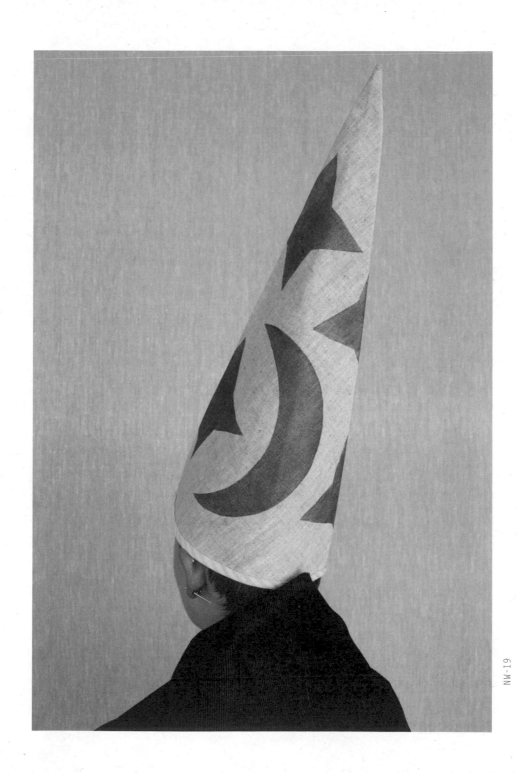

ARTIST'S ACKNOWLEDGMENTS

I would like to express my sincere thanks to the Freund family for making possible the Henry L. and Natalie E. Freund Visiting Artist program and to Bunny and Charles Burson for their generous contribution toward the accompanying exhibition, which provided me with the opportunity and the means to develop an entirely new body of work. At the Sam Fox School of Design & Visual Arts I would also like to thank Carmon Colangelo, Buzz Spector, and Ron Leax for their leadership and commitment to this program, as well as Sabine Eckmann at the Mildred Lane Kemper Art Museum for her curatorial oversight of the project and her thoughtful introduction to this catalog. Special thanks are due to Joan Hall at Island Press for inviting me to produce a print edition in conjunction with the project and for the energy and sense of adventure she brought to the process; to master printer Tom Reed for his patience and troubleshooting acumen; and to my father, Drake Smith, who heroically sewed the parachutes in the late night after-hours at work. I am deeply grateful to Lauren Adams for nominating me for this opportunity and for the productive dialogue and friendship that we have shared throughout the process of working together over the past year. Heartfelt thanks go out to Wendy Vogel for her insightful essay, which helped me better understand the implications of this project. I am especially grateful to the editor of this publication, Jane Neidhardt, who fearlessly engaged with the ideas in my work and in this exhibition at the deepest level, and who dusted off her old Remington typewriter to make the identification tags for the masks. Thanks are also due to editorial assistant Eileen G'Sell, and to Brett MacFadden and Scott Thorpe for their intelligent design of this book. There are many students who participated in this project by assisting with research, sewing the masks, and posing for portraits, including members of Lauren Adams's "Past Perfect, Present Tense" class and printmaking and drawing majors in the Sam Fox School, including Siena Baldi, Matt Barker, Liz Belen, Judit Bognar, Lindsay Deifik, John Early, Virginia Eckinger, Mary Ellsworth, Cary Euwer, Ryan Fabel, Katie Ford, Nick Francel, Jenie Gao, Trisha Gupta, Grace Hong, Hannah Ireland, Derrick Jensen, Rachel Krislov, Whitney Langsdon, Zak Marmalefsky, Laura Mart, Erin Mitchell, Jonathan Monroe-Cook, Becca Moore, Emily Moorhead, Jun Nakamura, Kathryn Neale, Lyndsay Nevins, Jennifer O'Neill, Katie Osburn, Jennifer Rich, Eleanor Ryburn, Donna Smith, Annie Stephens, Alexander Vitti, Kim Wardenburg, John Witty, and Bridgette Zou. I would also like to thank teaching assistants Aaron Bos-Wahl and Dani Kantrowitz, research assistant Madeline Mohre, and printing assistant Clyde Ashby. I'm indebted to Matt Gordon and the lab technicians at the Digital Fine Arts Studio at California College of the Arts for their help with printing the portraits, and to Tim Burnham for his work building the display cases. I'm greatly appreciative of the diligent efforts of chief registrar Rachel Keith, exhibition preparators Ron Weaver and Jan Hessel, and the entire staff of the Kemper Art Museum, in addition to the administrative support of Lori Turner and Sara Quigley at the Sam Fox School, and Flo Simpson at TravelPlex. I would also like to thank Brandon Anschultz, Lisa Bulawsky, Susan Colangelo, Meredith Malone, and Patricia Olynyk for their support and enthusiasm. Others who contributed to various aspects of this project include my studio assistants Renée Delores, Lydia Greer, Jennifer Hennesy, Adrianna Iantorno, Kate Nartker, and Charlene Polanco, as well as my sister Kathleen Smith and my mother Kitty Smith. Finally, most affectionate thanks go to Christina Linden, who encouraged me to pursue the circuitous line of inquiry that inspired this work, and who assisted me in every aspect of it.